The Art of Hand Lettering for Beginners

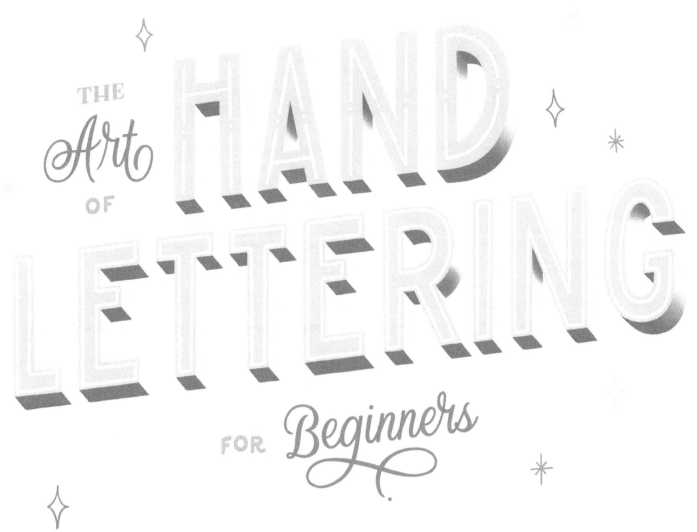

THE Art OF HAND LETTERING FOR Beginners

BEAUTIFUL PROJECTS & ESSENTIAL TECHNIQUES

JOANNA MUÑOZ

Foreword by Brooke Robinson

ROCKRIDGE PRESS

For my mom, who bolstered my handwriting skills as a child; my dad, who encouraged my love of drawing; and my husband, whose unending support always inspires me—I'm forever grateful.

For general information on our other products and services or to obtain technical support, please contact our Customer Care Department within the United States at (866) 744-2665, or outside the United States at (510) 253-0500.

Rockridge Press publishes its books in a variety of electronic and print formats. Some content that appears in print may not be available in electronic books, and vice versa.

TRADEMARKS: Rockridge Press and the Rockridge Press logo are trademarks or registered trademarks of Callisto Media Inc. and/or its affiliates, in the United States and other countries, and may not be used without written permission. All other trademarks are the property of their respective owners. Rockridge Press is not associated with any product or vendor mentioned in this book.

Interior and Cover Designer: Katy Brown
Photo Art Director: Amy Burditt
Editor: Katharine Moore
Production Editor: Andrew Yackira

All illustration and photography on page 99 courtesy of © 2018 Joanna Muñoz. Difference of interiors and cover photography © 2018 Jennifer Hale.

ISBN: Print 978-1-64152-210-6

Contents

Foreword

I've been an artist for the better half of my life and a designer for more than a decade, but it wasn't until the summer of 2012, on a bicycle trip down the West Coast of the United States, that my appreciation and admiration for hand lettering increased exponentially. Riding my bike from Canada to Mexico, I found that the West Coast was a treasure trove of lettering art, from hand-painted murals to hand-lettered signs and logos.

I began to curate the lettering arts in 2013 when I started my company, Goodtype. I very quickly found that I was one of hundreds of thousands of people who had taken a liking to hand lettering. Why had this art form gained such popularity? Hand lettering allows an artist or designer to express themselves in a distinct and special way. And it allows clients to own something custom and unique to their needs, giving them the solace of knowing that their design can't be exactly replicated.

I have admired Joanna's work since the beginning of Goodtype. As a curator of letterforms for the last five years, I've reviewed thousands of calligraphy and lettering styles, and Joanna's clean and distinct style has always stood out. She has been featured in the last two Goodtype books because her compositions bring a fresh and dynamic perspective to the table. Her lettering runs a gamut of styles, from traditional calligraphy to brush lettering to illustrative hand lettering.

Hand lettering is an imperfect art form, yet Joanna has a process that makes it look flawless. She can seamlessly transition from sketching with pencil and paper to using the ever popular iPad method. She is a true professional in this field, with infinite lettering wisdom and knowledge. *The Art of Hand Lettering for Beginners* is a true reflection of her experience, dedication, and passion, and will be a valuable resource no matter where you are on your design journey.

Hand lettering is a highly in-demand skill and the wave of the design future. In an overly digital world, the human touch of hand lettering is sought after time and time again by companies and individuals across the globe. There is no better time than now to integrate hand lettering into your skill set, and this book is a great first step.

—Brooke Robinson, chief curator and founder of Goodtype

Introduction

I've always loved drawing. I remember taking the Sunday comics section from my dad so I could draw characters from the comic strips. He'd buy supplies for me to doodle with and would often draw alongside me. My mom, while not as artistic, has lovely cursive handwriting and would have me practice writing the alphabet before I could go play. While I hated it then, I'm very thankful now. I didn't realize how much that muscle memory and attention to detail would pay off. But I *did* know, even at a young age, that I wanted to have a career in the arts. My heart is happiest when I create things by hand.

In college, I switched majors from computer science to graphic design once I found out there were classes where the professors encouraged you to draw ALL DAY. I wanted to illustrate children's books, but it was the early 2000s and everyone was moving toward all things digital. I followed that lead, and every job I've had since then has involved some form of digital design and media. I love what I do, but something was missing and I wasn't sure what.

Cut to my engagement in 2012—I decided I'd create our wedding stationery and signage, to give our wedding a personal touch. I taught myself calligraphy through online classes and in-person workshops. Because calligraphy and lettering are so closely related, it was only a matter of time before I stumbled across lettering. I was completely captivated and realized that this was what I had been missing. Lettering is the perfect combination of two things I've always been drawn to: writing the alphabet (thanks, Mom!) and drawing (thanks, Dad!). I threw myself into it and absorbed as much as possible through the few sources I could find. Through consistent, mindful practice, I turned what started out as a fun hobby into a successful freelance business.

And now, here we are! I want to share everything I've learned, and I hope this book can be the kind of asset for you that I wish I'd had when I first started. Use it to explore what you're drawn to and follow that path to find your own lettering voice and style. Before you know it, you'll be lettering like a pro!

The book has four sections that guide you through lettering step by step. Chapter 1 covers letterforms, terminology, and the tools to get you on your way. Chapter 2 has eight alphabets to use as guides, as well as tutorials to enhance your lettering (plus downloadable practice pages, available at http://callistomediabooks.com/HandLettering). Chapter 3 contains 20 projects to experiment with and put your new skills to use. And chapter 4 teaches you how to expand upon what you've learned to create your own unique style.

Take your time, be patient with yourself, practice with intent, and, above all else, have fun!

Learn the RULES LIKE A PRO, SO YOU CAN BREAK THEM LIKE AN Artist.

Lettering Basics

We're going to cover the ins and outs of lettering as an art form, from the structural elements that make up the letters to the proper terminology, and various styles of drawing to the tools and materials you'll use to create them. Understanding these concepts will help you make informed decisions when creating your lettering pieces . . . and once you learn the rules, it'll be way more fun to break them!

What Is Lettering?

Lettering is the art of *illustrating* letters, words, and phrases, and each element is drawn from scratch. Most pieces are created for a single use or a one-of-a-kind application, like a logo or a wedding sign. You don't have to have good handwriting to be a good lettering artist, but it *is* important to understand the structure of each letter and the basic rules of typography (the art and technique of arranging type) before you get started making something swoon-worthy enough to share.

DRAWN

Some people confuse lettering with calligraphy—both deal with letters and words, but the two are very different in technique. Where lettering is the art of *drawing* letters using multiple strokes, calligraphy is the art of *writing* letters in one fluid motion. Calligraphy requires dedicated practice (typically with a dip pen and ink) to establish and maintain the muscle memory needed to form letters in a visually expressive way. You may have noticed that calligraphic pieces have a consistent look throughout and a sense of rhythm and flow, created through the repetitive strokes used to write each letter.

WRITTEN

Calligraphy

Lettering, on the other hand, focuses on the composition as a whole. Each letter is drawn individually with a variety of tools, and the lettering styles used can be mixed and matched. While there may not be consistency from letter to letter or word to word, each aspect of the piece is carefully constructed to work together visually to result in a truly unique design tailored to a particular project.

Three of the most common lettering styles are serif, sans-serif, and script (see Calligraphy & Lettering Terms on page 5 for definitions of each). There are other categories, too, and so many substyles of those categories that it would take a long time (and a long book) to cover all of them. Instead, in this book you'll learn, practice, and use the three styles most often seen in modern hand lettering: brush lettering, faux calligraphy, and monoline lettering.

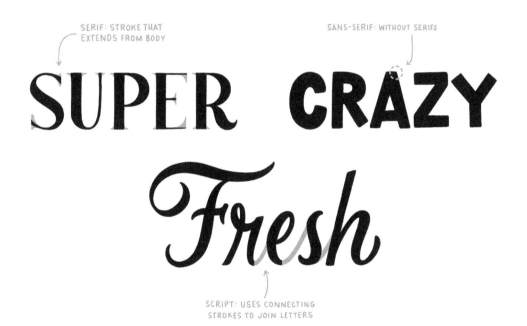

SERIF: STROKE THAT EXTENDS FROM BODY

SANS-SERIF: WITHOUT SERIFS

SCRIPT: USES CONNECTING STROKES TO JOIN LETTERS

BRUSH LETTERING is a popular style used by letterers. It has contrasting line weights (thin vs. thick line width) created by applying or releasing pressure on the brush pen or paintbrush. **FAUX CALLIGRAPHY** resembles traditional calligraphy, but rather than applying pressure to the nib of a pen, the thick strokes are colored in. **MONOLINE LETTERING** is typically produced with a round pen and has a consistent line weight from start to finish.

In the pages that follow, I'll cover all three styles and put them to use by creating super fun, real-world projects. There are so many ways you can use lettering—from greeting cards to custom stamps to home decorations to gifts for friends—and I'm excited to share the tips and tricks I've learned (mostly through trial and error!). You'll soon understand all the elements needed to create a cohesive composition and turn that into a polished, original work of art. Your only limit is your imagination!

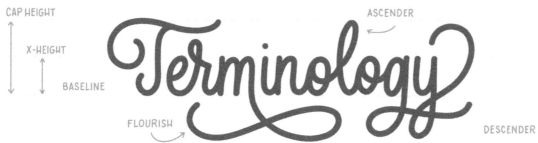

CAP HEIGHT

X-HEIGHT

BASELINE

Terminology

ASCENDER

FLOURISH

DESCENDER

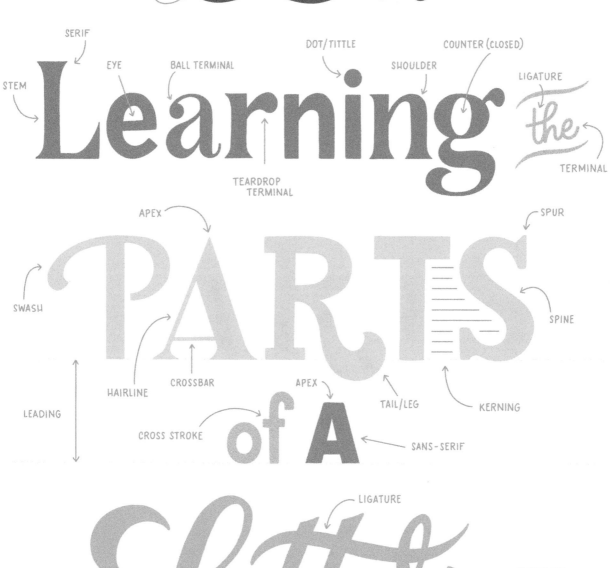

SERIF

STEM

EYE

BALL TERMINAL

DOT/TITTLE

SHOULDER

COUNTER (CLOSED)

LIGATURE

Learning *the*

TEARDROP TERMINAL

TERMINAL

APEX

SPUR

SWASH

PARTS

SPINE

HAIRLINE

CROSSBAR

APEX

TAIL/LEG

KERNING

LEADING

CROSS STROKE

of **A**

SANS-SERIF

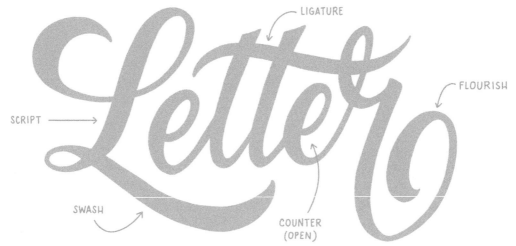

LIGATURE

FLOURISH

SCRIPT

Letter

SWASH

COUNTER (OPEN)

CALLIGRAPHY & LETTERING TERMS

APEX: a point at the top of a letterform where two strokes meet

ASCENDER: a portion of a letter that extends above the x-height

bfhkl

ASCENDER LINE: a line marking the height of the top of the ascender

BASELINE: line on which the letters "sit"

BOWL: a stroke that creates an enclosed curved space, e.g. in letters *b* and *d*

CAP HEIGHT: height of the flat-top capital letters (*H, E, F, T*)

COMPOUND CURVE: an overturn that

hmnvxy

transitions into an underturn stroke. Used in letters *h, m, n, v, x,* and *y*.

COUNTER: an area that is entirely or partially enclosed by a letterform, number, or symbol. Letters with closed counters include: *A, B, D, O, P, Q, R, a,*

BRaes

b, d, e, g, o, p, and *q*. Letters with open counters include: *c, f, h, s, e,* and *g*.

CROSSBAR: a horizontal stroke

DESCENDER: a portion of a letter that extends below the baseline

gjyz

DOT/TITTLE: a small, distinguishing mark on *i* and *j*

DOWNSTROKE: a thick stroke created by applying equal, full pressure in a downward motion

////////

HAIRLINE: a thin stroke

KERNING: the space between two letters

LEAD-IN OR ENTRANCE STROKE: a slightly curved upstroke that begins at the baseline and curves toward the x-height. Used to start many letters and

entrance

connect strokes to make words.

LEADING: the space between two baselines of type

LETTERFORM: the shape of a letter

LIGATURE: two or more characters joined together to make one character

NEGATIVE SPACE: the area in and around letterforms

OVERTURN: an upside-down u-shaped stroke created by a thin upstroke that transitions into a thick downstroke. Used in letters *m* and *n*.

SANS-SERIF: a letter without any extending features or serifs

SCRIPT: letters joined together in a continuous, fluid motion (i.e. cursive)

SERIF: a short line or stroke extending from the main body of a letterform

UNDERTURN: a u-shaped stroke created by a thick downstroke that transitions into a hairline upstroke. Used in letters

a, i, u, w, d, and *t*.

UPSTROKE: a thin stroke created by applying little or no pressure in an

upward motion

TERMINAL: the end of a stroke that doesn't include a serif

X-HEIGHT: the height of the lower-case letters, typically measured by the lowercase *x*.

Lettering Styles

Now that you're more familiar with the terms you'll see in the book, let's move on to lettering styles.

BRUSH LETTERING

Brush lettering is, as the name implies, lettering created with a brush pen or paintbrush. Applying varying degrees of pressure when drawing lines allows for the creation of thick and thin strokes. This type of lettering can be used for projects that need a calligraphic style with varying line weights. Transitioning from a thin stroke to a thick stroke in one smooth motion can be tricky at first, but once you get the hang of it, you'll easily be able to create gorgeous letters. All you need for this form of lettering is a brush pen or a paintbrush loaded with paint or ink.

TIP! HOLD THE BRUSH PEN AT AN ANGLE

In order to create that change in line weight, you need to apply more pressure on the downstroke and less pressure on the upstroke of your letterforms. Keep practicing these foundational strokes until you feel comfortable with the brush and have established a rhythm to the flow. Lettering tools are made from a variety of materials, and each responds differently. Warm up your muscles with a few exercises each time you try a new brush lettering tool or begin a new project.

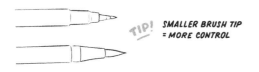

TIP! SMALLER BRUSH TIP = MORE CONTROL

As with traditional calligraphy, establishing muscle memory is important in brush lettering, allowing you to join letterforms together with a continuous stroke that gives them that elegant script look. Set some time aside each day to practice. Be mindful about the strokes you're making, and don't rush through the exercises just to get them done. Practice makes progress!

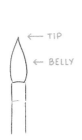

← TIP

← BELLY

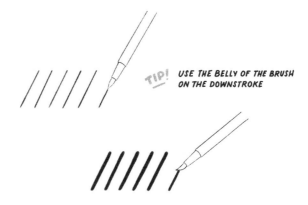

TIP! USE THE BELLY OF THE BRUSH ON THE DOWNSTROKE

Brush Lettering Strokes

UPSTROKE – NO PRESSURE

/ / / / /

DOWNSTROKE – APPLY PRESSURE

/ / / / /

UNDERTURN

u u u u u

OVERTURN

n n n n n

COMPOUND CURVE

v v v v v

O-FORM

o o o o o

ASCENDING STEM LOOP

p p p p p

DESCENDING STEM LOOP

f f f f f

COMBINE FOUNDATIONAL STROKES TO FORM LETTERS

o + v = a

o + l + v = d

l + v = n

o + f = g

v + v = w

MONOLINE LETTERING

Monoline lettering is a style in which the line remains the same weight from beginning to end. It's perfect for keeping designs simple and clean. You can create script, serif, or sans-serif monoline styles, as long as the line weight stays consistent. If you want to create monoline lettering with a pen, you'll need a round-tip version that won't change line weight when you apply pressure—a Sharpie is the perfect place to start!

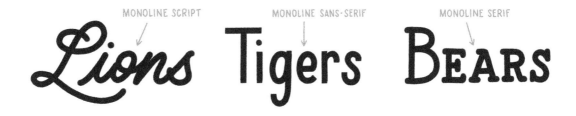

MONOLINE SCRIPT MONOLINE SANS-SERIF MONOLINE SERIF

Lions Tigers BEARS

FAUX CALLIGRAPHY

Faux calligraphy is all the rage these days, and for good reason—it resembles traditional calligraphy, but you don't need any fancy tools. With traditional calligraphy, establishing control of the ink flowing through the nib, ensuring the correct angle of the pointed pen, and maintaining proper letter structure is challenging; it takes a long time to even get comfortable, much less master the technique. Faux calligraphy follows the same rules and guides as traditional calligraphy, but we simulate the thick downstrokes by filling in the area with a pen rather than applying pressure with a brush or nib. This style is best for projects that call for an elegant or fun script, like wedding place cards or menus. Just use a non-brush tip pen at whichever point size you need for your project.

1. DRAW A LETTER OR WORD 2. ADD DOWNSTROKES

Magic *Magic*

3. FILL IT IN!

Magic

Tools & Materials

Since lettering is the art of drawing letters, you really don't need anything but a pencil and plain paper to dive right in. But for the purposes of this book and the projects in the next chapter, you'll need some basic supplies; you can add more once you get comfortable experimenting with styles and exploring your creativity.

ESSENTIALS

Almost all letterers stock their go-to kit with the basics. There are endless supplies for you to choose from, and each has their pros and cons. I encourage you to play around with as many tools as you can to find the ones you're most comfortable using. Here are my must-haves and favorite types/brands that I use and highly recommend:

PENCIL: My #1 tool for sketching. Mechanical pencils are low-maintenance and Blackwings are luxurious, but any pencil will do!

▶ Alvin Draft-Matic .5mm mechanical pencil
▶ Blackwing

ERASER: For cleaning up your sketches because, well, nobody's perfect. This is your new best friend!

▶ Tuff Stuff eraser stick
▶ Staedtler Mars Plastic

RULER: Perfect for setting up guidelines (because even lettering artists with years of experience can't draw a straight line).

▶ Westcott transparent ruler
▶ Metal ruler—any brand

FINE-POINT PENS: These are a must for detailed drawings, and there are a bajillion different kinds. I prefer the six-piece Micron pen set.

▶ Sakura Pigma Micron
▶ Sharpie fine-point
▶ Gelly Roll
▶ Uni-Ball

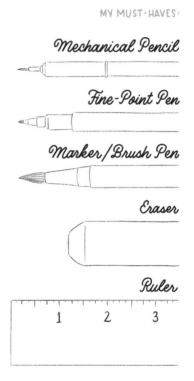

MY MUST-HAVES:

Mechanical Pencil

Fine-Point Pen

Marker/Brush Pen

Eraser

Ruler

MARKERS: Great for monoline work, bold lines, and filling in large shapes.

- ▶ Sharpie
- ▶ Sakura Pigma Micron Graphic

SMALL-NIB BRUSH PENS: My absolute favorites. They have shorter bristles and give you more control when creating strokes.

- ▶ Tombow Fudenosuke, soft tip (my #1 brush pen)
- ▶ Tombow Fudenosuke, hard tip
- ▶ Zebra Fude

LARGE-NIB BRUSH PENS: Perfect for creating heavy downstrokes and lettering on a larger scale. The large bristles cover more ground than the smaller-nib brush pens can.

- ▶ Tombow Dual
- ▶ Copic Sketch Markers

BRUSHES: A small round, a large round, and a wide flat brush should have you covered.

- ▶ Size 18/0 or 10/0 round or spotter brush
- ▶ Size 4 or 6 round brush
- ▶ Aquash water brush

SKETCHBOOK: Every idea should start with a sketch, and sketchbooks make jotting down ideas easy! Dot grids are my fave.

- ▶ Moleskine
- ▶ Baron Fig

PAPER: Regular printer paper is great for sketching; tracing paper is a must for making adjustments; layout bond is slightly transparent and can handle pencil, pen, or marker; laser paper is opaque, heavy, and smooth; and cardstock is heavy and perfect for final projects.

- ▶ Regular printer paper
- ▶ Tracing paper
- ▶ Layout bond
- ▶ Laser paper
- ▶ Cardstock

Extras

You definitely don't need more than the essentials to get started, but if you want to elevate your style and create more advanced and intricate designs, try the materials below and see what resonates. There's no wrong or right way to create artwork, so experiment to your heart's content!

PAINT PENS: Perfect for painting details with more control and without the mess of brushes and paint.

▶ DecoColor
▶ Sakura Pen-Touch
▶ Zig Painty Twin
▶ Sharpie oil-based paint marker
▶ Molotow acrylic paint markers
▶ Krink

CHALK: Chalk sticks are easy to use, chalk pens are great for details, and chalk pencils are perfect for fine lines.

▶ Chalk sticks (any brand)
▶ Bistro Chalk Marker
▶ General's Pastel Chalk Pencil

INK: Great for brush lettering with a paintbrush. Offers an opaque or translucent finish, depending on the ink used.

▶ Higgins Eternal Permanent Black Ink
▶ Moon Palace Sumi Ink
▶ Dr. Ph. Martin's Bleedproof White

WATERCOLORS: These require the use of heavy cardstock or watercolor paper to prevent paint bleeding or paper warping. Often translucent, so they can show mistakes, but can be reworked with water.

▶ Talens watercolor pen sets
▶ Derwent watercolor pencils
▶ Fabriano watercolor paper

ACRYLICS: An opaque medium that can be used to paint on virtually anything (paper, wood, glass, plastic, etc.). Dries quickly, becomes waterproof when dry, and cannot be reworked.

- ▶ DecoArt
- ▶ Craft Smart

TAPE: For those moments when you want your work to stay put.

- ▶ Washi tape (won't tear pages)
- ▶ Masking/painter's Tape (good for large projects)

X-ACTO KNIFE: Best for detailed and precise paper cutting.

BONE FOLDER: Dull-edged tool used for folding or creasing paper.

LIGHTBOX: The backlight provided by the lightbox makes images easier to trace. Tape your sketch down, tape a blank piece of paper on top, turn on the lightbox, and trace away!

- ▶ Huion

PAPER CUTTER: A guillotine-style paper trimmer that can measure and cut several sheets at the same time. It's a huge timesaver, and you'll thank me later. I promise.

- ▶ Swingline

Learn Your ABCs

Now that you're familiar with the structure of letters and the tools you'll be using, let's jump to the letters themselves. This chapter has four sections: The first includes eight alphabets to trace and practice and apply to the projects later in the book. The second shows you how to connect letters with entrance and exit strokes, which establish a rhythm to your drawing. The third section explains how to add flourishes and illustrations. The fourth gives you an overview of the process of creating a finished lettered piece.

Use the eight alphabets in this first section as a jumping-off point. Letters can be adjusted and altered to create any number of styles based on one alphabet. You can make the letters fat or thin, tall or short, curvy or straight—the list goes on and on. Remember: Use the letterforms provided to learn from and experiment with.

Daniel

A sans-serif monoline style that's great for keeping things simple, fun, and low-key. This style is perfect for adding a hand-drawn element without all the frills.

Mitchell

Another sans-serif, monoline style, Mitchell has a heavy weight to its letterforms and is great for simple pieces that pack a punch.

Cooks

Cooks is a serif-style alphabet and can be paired with sans-serif styles to provide a contrast in shapes. The classic letterforms are great for wedding projects and add an elevated look.

Palms

Another serif, Palms has high-contrast line weights to give it a dramatic effect. The capital letterforms are great for monogram projects.

Rogue

A laid-back brush script, Rogue emulates the loose style of sign painter lettering. Use Rogue for projects that need a quick and easy script style with simple charm.

Riley

Riley is a script lettering style, offering a happy medium between elegant faux calligraphy and casual brush alphabets. It's perfect for those fancy but fun occasions.

Seaside

Seaside is a faux calligraphic script, perfect for casual projects that need a special touch.

Swell

Swell is an elegant script typeface with curling entrance strokes and long exit strokes. This alphabet is best for pieces that need a smooth, flowing style to tie everything together.

To download printable practice pages for all the alphabets listed here, visit http://callistomediabooks.com/HandLettering.

LEARNING TO LETTER

Here are a few tips and tricks I've learned along the way that will help you when you begin to draw your letterforms.

SIMPLIFY INTO SHAPES: All letters are made up of a combination of three basic shapes: a circle, a square (or rectangle), and a triangle. You can break down the drawing process by combining these three basic shapes to create each letterform.

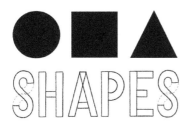

OVERSHOOT: Lettering often requires you to compensate for the optical illusions created by certain shapes. Round and pointed letterforms need to extend slightly above or below the cap height, x-height, or baseline so that the letters make the same amount of contact with the guidelines as the flat shapes do.

KERNING: Adjusting the space between letters (also known as kerning) plays an important role in legibility. Depending on a letter's overall shape, some letters need to sit closer together to avoid awkwardly large areas of white space.

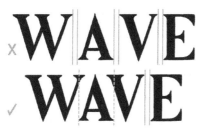

LEGIBILITY: The key to good lettering is making sure your audience can clearly read what you're trying to say. Keep loops, swashes, flourishes, and the like to a minimum.

DIAGONAL LETTERFORMS: Letters with diagonal strokes can be confusing to draw at first. Be sure to add weight to the downstrokes to avoid funky-looking shapes.

BUILDING LETTERS: First, draw the skeleton or frame of the letter. Then add weight and thicken the shape as needed, and add stylistic details, like serifs. Finish things off with decorative elements.

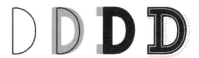

3-D STYLING: To achieve this look, decide where your light source is coming from to determine which way your shadows, drop lines, or extrusions should go.

Daniel

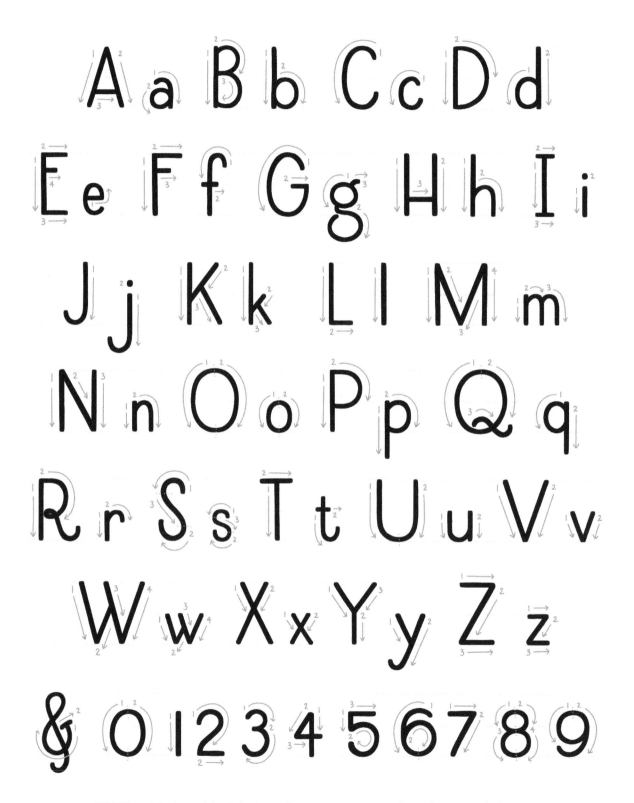

TIP! Play with the width of the letterforms to create a condensed or expanded version.

18 The Art of Hand Lettering for Beginners

Aa Bb Cc Dd

Ee Ff Gg Hh

Ii Jj Kk Ll

Mm Nn Oo Pp

Qq Rr Ss Tt

Uu Vv Ww Xx

Yy Zz &

0 1 2 3 4 5 6 7 8 9

Mitchell

Aa Bb Cc Dd
Ee Ff Gg Hh Ii
Jj Kk Ll Mm
Nn Oo Pp Qq
Rr Ss Tt Uu Vv
Ww Xx Yy Zz
& 0 1 2 3 4 5 6 7 8 9

TIP! Round out the endpoints of each stroke to give the alphabet a softer look.

A a B b C c D d

E e F f G g H h

I i J j K k L l

M m N n O o P p

Q q R r S s T t

U u V v W w X x

Y y Z z &

0 1 2 3 4 5 6 7 8 9

Cooks

Aa Bb Cc Dd

Ee Ff Gg Hh Ii

Jj Kk Ll Mm

Nn Oo Pp Qq

Rr Ss Tt Uu Vv

Ww Xx Yy Zz

& 0123456789

TIP! Thicken the serifs into bolder, block-like shapes to create a slab serif style.

Aa Bb Cc Dd
Ee Ff Gg Hh
Ii Jj Kk Ll
Mm Nn Oo Pp
Qq Rr Ss Tt
Uu Vv Ww Xx
Yy Zz &
0123456789

Palms

A a B b C c D d
E e F f G g H h I i
J j K k L l M m
N n O o P p Q q
R r S s T t U u V v
W w X x Y y Z z
& 0 1 2 3 4 5 6 7 8 9

TIP! Increase the contrast in thick and thin line weights for an even more eye-catching effect.

The Art of Hand Lettering for Beginners

Aa Bb Cc Dd

Ee Ff Gg Hh

Ii Jj Kk Ll

Mm Nn Oo Pp

Qq Rr Ss Tt

Uu Vv Ww Xx

Yy Zz &

0 1 2 3 4 5 6 7 8 9

Rogue

A a B b C c D d

E e F f G g H h I i

J j K k L l M m

N n O o P p Q q

R r S s T t U u V v

W w X x Y y Z z

& 0 1 2 3 4 5 6 7 8 9

TIP! Play with angles by pushing the letterforms farther to the right to create motion.

A a B b C c D d

E e F f G g H h

I i J j K k L l

M m N n O o P p

Q q R r S s T t

U u V v W w X x

Y y Z z &

0 1 2 3 4 5 6 7 8 9

Riley

Aa Bb Cc Dd
Ee Ff Gg Hh Ii
Jj Kk Ll Mm
Nn Oo Pp Qq
Rr Ss Tt Uu Vv
Ww Xx Yy Zz
& 0 1 2 3 4 5 6 7 8 9

TIP! Experiment with the loopy shapes, and create larger flourishes.

Aa Bb Cc Dd

Ee Ff Gg Hh

Ii Jj Kk Ll

Mm Nn Oo Pp

Qq Rr Ss Tt

Uu Vv Ww Xx

Yy Zz

0 1 2 3 4 5 6 7 8 9

Seaside

A a B b C c D d
E e F f G g H h I i
J j K k L l M m
N n O o P p Q q
R r S s T t U u V v
W w X x Y y Z z
& 0 1 2 3 4 5 6 7 8 9

TIP! Double up the downstrokes to create a high-contrast style.

Aa Bb Cc Dd

Ee Ff Gg Hh

Ii Jj Kk Ll

Mm Nn Oo Pp

Qq Rr Ss Tt

Uu Vv Ww Xx

Yy Zz

1234567890

Swell

A a B b C c D d
E e F f G g H h I i
J j K k L l M m
N n O o P p Q q
R r S s T t U u V v
W w X x Y y Z z
& 0 1 2 3 4 5 6 7 8 9

TIP! Redraw this alphabet with a vertical axis, and you'll end up with a bouncier version.

The Art of Hand Lettering for Beginners

Aa Bb Cc Dd

Ee Ff Gg Hh

Ii Jj Kk Ll

Mm Nn Oo Pp

Qq Rr Ss Tt

Uu Vv Ww Xx

Yy Zz &

0 1 2 3 4 5 6 7 8 9

The Art of Hand Lettering for Beginners

Connecting Letters

When drawing in a script lettering style, connecting strokes tie everything together in one fluid motion. Entrance strokes lead into the letter, while exit strokes move you on to the next letter, word, or phrase. These two strokes are among the fundamental strokes you'll need to properly draw script styles, and they give your lettering a smooth and continuous look and feel. The entrance stroke is a thin upstroke that starts at the baseline and ends at the x-height. The exit stroke can be a short stroke that connects one letter to another on the underturn (or u-turn) or a long, elongated stroke at the end of a word as a simple flourish.

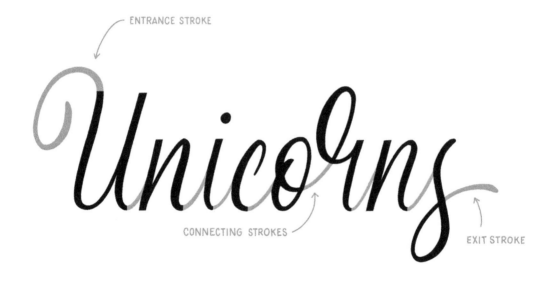

ENTRANCE STROKE

CONNECTING STROKES

EXIT STROKE

Flourishes & Illustrations

Flourishes can enhance your lettering in so many ways. You can give your artwork more character and detail by adding flourishes to certain letters with big loops and swirls. If your piece has empty areas that need to be filled, try using flourishes to fill those gaps. This is a great tactic when addressing envelopes, for example, especially if your lettering is off-center (which can happen more often than you think). Think of flourishes as design elements extending from your letterforms, which you can use to balance your composition and bring your piece together. The trick is to not overdo it, otherwise the flourishes might distract from the centerpiece of your work—your lettering.

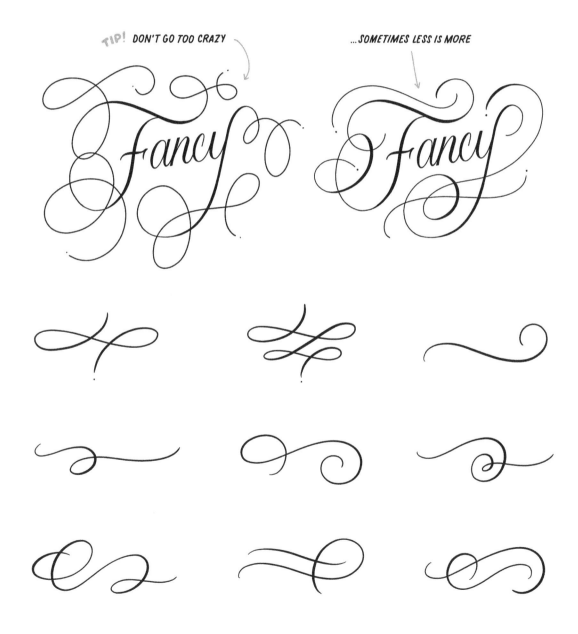

Incorporating illustrations into your design is another wonderful way to complement your hand lettering. You can create a more robust piece without relying on just the letters. Think about what you're writing and how illustrations can tie into it. If you letter a quote about flowers, draw flowers growing out of the letters and intertwining into an outer border. Don't be afraid to break and blur the boundaries of your letters so the illustrations meld with those shapes in a natural way.

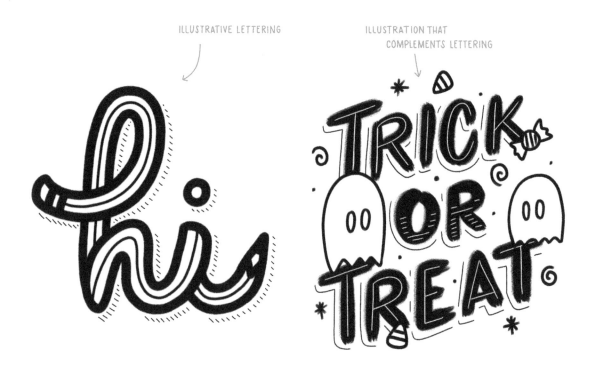

ILLUSTRATIVE LETTERING

ILLUSTRATION THAT COMPLEMENTS LETTERING

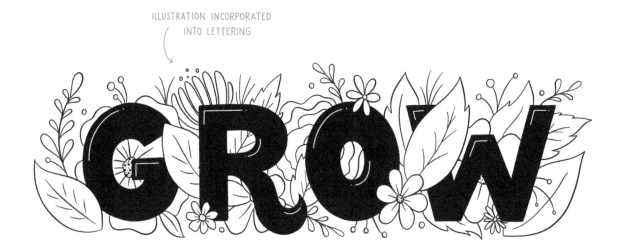

ILLUSTRATION INCORPORATED INTO LETTERING

Process

Each artist has their own approach to designing a hand-lettered piece, and some projects require more steps than others. There's no right or wrong way when it comes to creativity—just find what works best for you! Below is an overview of my process to help you on your way.

CONCEPT & BRAINSTORMING

First, pick out what word or phrase you want to letter. If you're new to lettering, keep it short and sweet so you can focus your attention on the basics. I chose a pangram (it contains all the letters in the alphabet) for this example, and started with a brainstorm session to get my creativity going first. This can mean jotting down words that come to mind (adjectives, nouns, feelings, etc.) or surfing the Internet for imagery and inspiration.

VISUAL HIERARCHY & THUMBNAILS

The human brain is wired to read the biggest things first in order to absorb information in the shortest time possible. You'll need to decide which words are the most important and give them all the glory—this is called visual hierarchy. The elements in your piece should work together to guide the viewer's eye from one word to the next in a fluid motion. Non-descriptive words (like *the, as, of, in*, etc.) are often the least important and can be used to fill in negative space.

There are an infinite number of ways to draw the same thing, so how do we start? Thumbnails are quick and dirty sketches that are great for working through layout ideas. Keeping them small is ideal and they don't have to be pretty. The point is to work quickly and get those ideas out onto the page so you know what works and what doesn't before you move to a larger scale. You can also use shapes to represent words to speed things up.

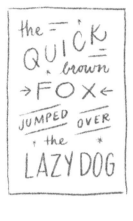
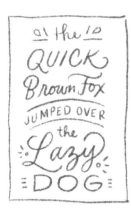

SKETCHES

Now that you have a concept and a layout picked out, it's time to start sketching.

GUIDELINES: Set up your guidelines and draw in your baselines, x-heights, cap heights, and diagonals (if you're using italics or script lettering) to keep things consistent. This is the foundation of your piece.

FRAMEWORK: Sketch out the skeleton of the letters and focus on structure, width, and proportion. Try to limit your lettering styles to two or three to create a nice visual contrast. You can add in decorative elements to help fill in negative space, but don't worry about every detail just yet.

BUILD: If your structure looks good, you can start building out your letterforms by adding or removing weight from each letter—make them thick or thin as needed for your layout. Keep making adjustments as needed. Nothing is set in stone! I find that using tracing paper to make adjustments is much easier than erasing everything and starting from scratch. I lightly draw in decorative elements (serifs, flourishes, shadows, etc.) in this stage to make sure everything works nicely together.

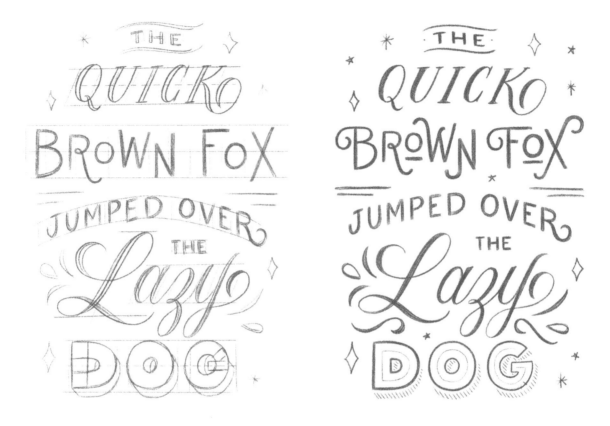

REFINE: The piece should be in a good place by this point, so begin refining your drawing by smoothing out curves and solidifying those decorative elements.

FINALIZE: Voila! That's it! You can ink your piece directly, scan and color it digitally, or redraw everything in a vector-drawing program like Illustrator. Now that you have an idea of what my process looks like, adapt it to suit your needs and go for it!

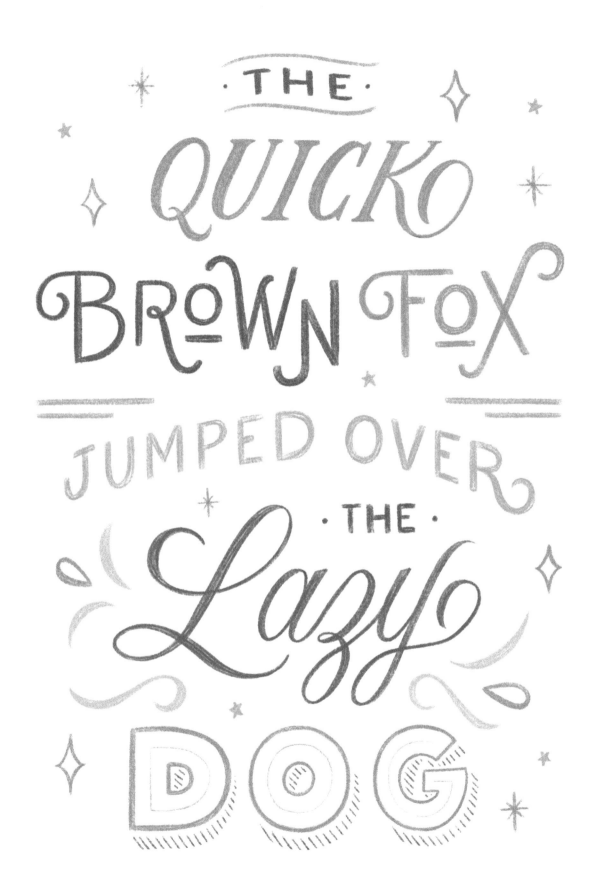

THE QUICK BROWN FOX JUMPED OVER THE Lazy DOG

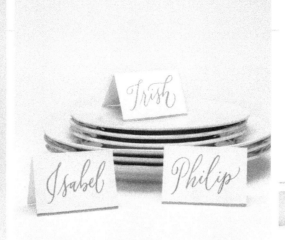

Thanks A Bunch!

Trish
Isabel
Philip

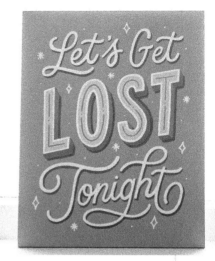

Let's Get LOST Tonight

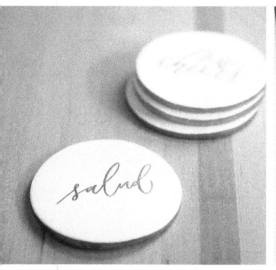

salud

Make IT Happen

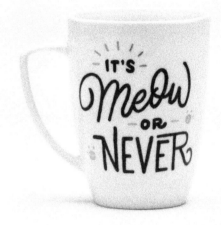

IT'S Meow OR NEVER

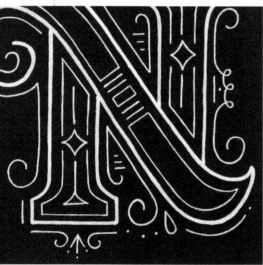

Super Rad Incredible Congrats Amazing Incredible Super happy yaass exciting Rad Congrats Amazing Incredible Super Rad Congrats Amazing Congrats Amazing Incredible Rad Congrats Amazing

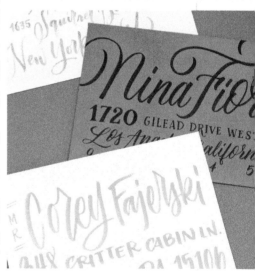

1635 Squirrel New York

Nina Fio 1720 GILEAD DRIVE WEST Los An California

Corey Fajerski 3118 CRITTER CABIN LN.

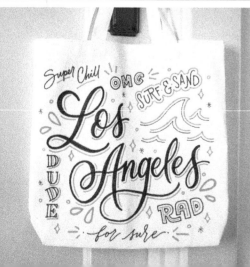

Super Chill OMG SURF & SAND Los Angeles DUDE RAD for sure.

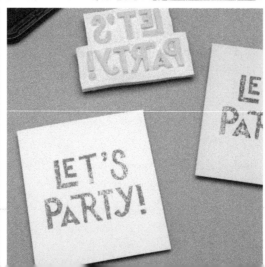

LET'S PARTY!

LET'S PARTY!

LE PAT

Raegan

Make Beautiful Projects

It's time to take the fundamentals from chapter 1 and pair them with the alphabets and techniques in chapter 2 to create the 20 projects in this chapter! The projects start out fairly easy, using basic tools and materials you probably have around the house, and gradually increase in difficulty, testing your skills and introducing you to intermediate tools.

Every project in this book has the same structure to guide you through the process in an easy-to-follow manner. Each tutorial has an introduction, a list of materials, step-by-step instructions, and tips and tricks. Before you jump in, remember to always start with sketches first to nail down ideas. Draw your piece to scale if needed to save yourself time and more work. Now let's have some fun!

Oh-So Grateful!

THANK-YOU CARD

In today's world of texts and emails, a handmade card with a handwritten note inside is an especially meaningful way to communicate. Remember making cards as kids? As we grow up, we often forget how easy it is to make things ourselves using tools already at our disposal. The result is less expensive than anything you can buy in a store, and you can personalize it in countless ways.

MATERIALS

- Pencil
- Scratch paper
- Cardstock
- Scissors or X-ACTO knife
- Black brush pen
- Fine-point pen
- Eraser
- Colored markers

ALPHABET

- Rogue (page 34)

METHOD

1. Before you jump in with your brush pen, practice your lettering with a pencil on a scratch piece of paper using the Rogue alphabet for reference. Try different layouts to find the one that works best for you.

2. If you don't have blank greeting cards available, cut a 9-by-6.5-inch rectangle out of a piece of cardstock using scissors or an X-ACTO knife. When folded, the card should be 4.5 inches wide and 6.5 inches tall.

3. Lightly draw guidelines on the card with your pencil—and, if your lettering is slanted, a few guides to denote the slant of your letters so the angles stay consistent.

4. Sketch your thank-you phrase on the front of the card and trace over it with the brush pen. Take your time and remember the foundational strokes you learned earlier.

5. Use a fine-point pen to smooth out any wonky lines, then let your piece air dry and erase your guides. Add different colored dots with marker pens for a confetti feel!

 TIP! If you're new to brush pens, try the Tombow Fudenosuke (hard tip). The smaller, stiffer brush tip offers more control when lettering.

 VARIATION: Once you get the hang of using brush pens, try a version using a paintbrush and ink to see how the two styles differ.

Thanks
A Bunch!

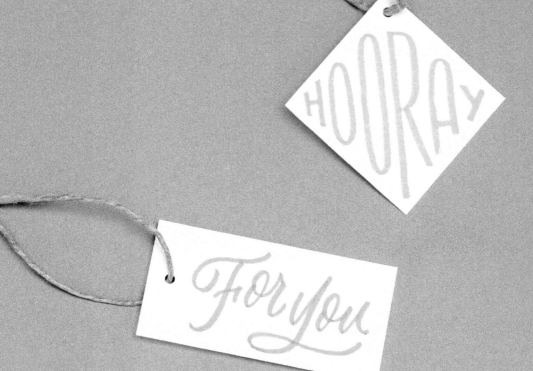

TIP: You can opt to draw repeated letters (like the s in *kisses*) in different ways to break up the monotony in your design.

Nifty-Gifty

GIFT TAGS

Gift tags are a quick and cute way to personalize gifts. There's also no limit to what you can create—you can make tags that are large or small with round or rectangular shapes, and they can complement a theme or create a fun pop of color or contrast. If you have multiple gifts that need tags (like holiday presents), mixing and matching designs to create a full set is simple and takes personalization to another level.

MATERIALS

- Cardstock
- Scissors
- Hole punch
- Scratch paper
- Pencil
- Brush pen and/or markers
- Thread, twine, or yarn

ALPHABET

- Riley (page 39), Mitchell (page 22), Palms (page 30), or Rogue (page 34)

METHOD

1. Cut the cardstock into four different shapes in your desired size(s). I made a 2-inch square, a 2-inch diamond, a 3-by-1.5-inch rectangle, and a long, skinny (3.75-by-1-inch) rectangle for my set of gift tags. If you want to use a traditional shape, trim the corners on one side of a rectangle.

2. Punch a hole near the top of the tag so you can tie it to your gift. This also helps you gauge how much actual writing space you have.

3. Don't forget to start with loose sketches on scratch paper (see page 55). Lightly sketch your lettering on the gift tags with a pencil and trace over them with a brush pen or marker of your choice.

4. Feed thread, twine, or yarn through the hole in the gift tags, and tie them to your gifts.

VARIATION: Create a cohesive set of gift tags by changing one of the elements but keeping the other element(s) consistent. For example, you can use different shapes for the tags but keep the lettering style the same, or stick to the same color family for the paper or ink.

Annnd . . . That's a Wrap!

WRAPPING PAPER

Creating your own wrapping paper is a really easy way to show someone you've put extra effort into their present. You can create custom wrapping paper for every occasion under the sun using a combination of paper types, textures, colors, and patterns, paired with any of the alphabets in this book, or even one of your own.

MATERIALS

- Plain paper or plain wrapping paper roll
- Scissors
- Washi tape
- Gelly Roll pen, brush pen, or marker

ALPHABET

- Rogue (page 34)

METHOD

1. Cut your paper down to size and tape it to a flat surface with your washi tape.

2. Decide what you want to letter, and begin writing out your word(s) from one end of the page to the other, using a pen or marker.

3. Create another line of words below your first line, and repeat until you fill the sheet. Shift your lines of text so the words are staggered, rather than perfectly aligned.

4. Let the ink dry completely, and then wrap your present!

 TIP! The bigger the marker, the less you'll have to draw on your page. (I may have learned this the hard way . . .)

 VARIATION: You can nix the pattern idea altogether and letter your word or phrase in multiple sizes and directions for a loose, haphazard style.

Shower Me with Love

BUNTING

Need a quick solution for party decorations, but don't have time to run to the store? Don't fret—you can create a simple piece of décor to celebrate a new arrival, milestone, or any event with materials you probably already have! This DIY bunting is a cute way to personalize a party without too much fuss. Customize the bunting to match your party theme by carrying over the same colors you used in your invitations or gift wrap, tying everything together for a cohesive look.

MATERIALS

- Pencil
- Ruler
- Heavy cardstock (any color)
- Scissors or paper cutter (see Tip)
- Light-colored cardstock
- Brush pen (Tombow Dual recommended)
- Eraser
- Hole punch
- Yarn, string, or twine

ALPHABET

- Mitchell (page 22) or Rogue (page 34)

METHOD

1. Start by creating a template. With a pencil and ruler, draw a triangle on a piece of heavy cardstock. The bunting template I made is 6 inches wide and 7 inches tall. Cut out the template using scissors or a paper cutter.

2. Trace the template on the light-colored cardstock, and cut out 7 triangles, one for each of the letters needed for "HEY BABY," plus a few extras in case you need them.

3. Before drawing the letters on the bunting pieces with the brush pen, lightly sketch each letter on the triangles in pencil. I typically prefer the Mitchell alphabet for this project, but use whichever alphabet works best for your theme.

4. Go over your pencil marks with the Tombow Dual brush pen, using the brush tip side. Hold the pen at a low angle, so you're using the sides of the brush when creating the downstrokes. You want to create thick lines a partygoer can see from far away, so double up the strokes if needed.

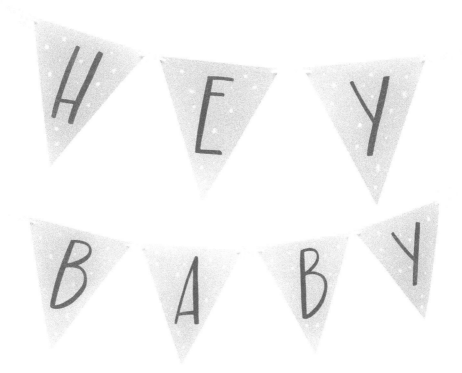

5. Let the ink dry, and erase any stray pencil lines.

6. Sometimes the brush bristles catch on the page and create wonky lines. You can keep them for a carefree look or clean them up by using the round-tip side of the Tombow. Short, quick strokes will give you more control when doing these touch-ups.

7. With a hole punch, punch a hole in both corners of the top of the bunting triangles, and thread the yarn, string, or twine through the holes. Hang and enjoy!

TIP! Invest in a paper cutter! Trimming paper can be tedious and an inefficient use of your time. Paper cutters are super helpful, especially when slicing and dicing multiple sheets. They have a flat surface with built-in rulers and a guillotine-like blade, which makes trimming and chopping a breeze.

VARIATION: Spice up your bunting by adding decorative elements. I used a white uni-ball Signo broad point gel pen to draw starbursts and filled circles to create subtle texture and contrast.

Pushing the Envelope

ENVELOPE LINERS

An envelope liner is an easy way to add some extra oomph to your custom invitations or greeting cards. Liners can be made from one solid color or a heavily designed piece. You can paint or illustrate designs and patterns or, as here, draw letterforms for a personalized touch. In this project, we letter "thank you" in several languages to complement a thank-you card (see page 60).

MATERIALS

- Envelope
- Pencil
- Plain paper
- Brush pen
- Scissors
- Eraser
- Glue stick or double-sided tape

ALPHABET

- Rogue (page 34)

METHOD

1. Take the envelope you'll be using, open the flap, and use a pencil to trace the shape of the open envelope onto a piece of plain paper.

2. Begin lettering across the piece of paper with a brush pen, using the Rogue alphabet for reference. Make sure your lettering extends all the way across the envelope outline. Draw baselines as a guide if you're not yet comfortable lettering freehand.

3. Cut out your envelope outline with scissors and trim off ⅛ inch from the left and right sides and ¾ inch off the bottom to allow the liner to slip in easily. Leave the top as is—this is the part people will see when they open your envelope. Erase any guides.

4. Slip the liner all the way into the envelope, and fold the flap down to crease the liner.

5. Use a glue stick or double-sided tape to secure the top portion of the liner to the envelope. (You don't have to glue or tape down the entire liner.) And voilà, you're all set!

 TIP! There are tons of different envelopes, and one size does not fit all when it comes to liners. You might need to adjust the amount of paper you trim from the edges, depending on your envelope.

 VARIATION: If your envelope is white, use a sheet of colored paper as your liner, or vice versa, to create a colorful contrast.

Swanky Snail Mail

ADDRESSING ENVELOPES

In today's need-to-get-things-done-ASAP multitasking world, snail mail is a dying art form. It's so much easier and way more convenient to call someone or shoot over a text or e-mail. Sending a card takes time, effort, and, more importantly, thought and intention. It says, "Hey! I like you enough to take time out of my day to do this." The front of the envelope is also the perfect canvas to show off your brand-new hand lettering skills to the world, or maybe just to your letter carrier!

MATERIALS

- Scratch paper
- Pencil
- Envelope
- Chalk pencil (for dark envelopes)
- Ruler
- Brush pen or paintbrush and ink

ALPHABET

- Various

METHOD

1. Let's talk names. Is the envelope for a guy or girl? Will you be sending it to one person, two people, or a family? Will it be formal (Mr. and Mrs.) or informal? Grab your scratch paper and pencil and try different ways to display the recipient's name(s) and addresses, deciding what kind of style and tone you want to convey. Remember that envelopes that can't be read by the machine at the post office go to a postal service worker for sorting, so the address has to be 100 percent legible.

2. Before you begin drawing, place a postage stamp in the top right corner of the envelope so you know exactly how much space you have to work with.

3. Lightly sketch out baseline guides, the name(s), and the address on the envelope with a pencil. If the envelope is dark, use a chalk pencil. I like to make the names the most eye-catching part of the envelope and use the address to fill in the remaining negative space. Feel free to experiment here by lettering on a diagonal or curve and adding illustrations like banners or starbursts, too.

4. Grab your brush pen or paintbrush and ink and trace over your sketches with your choice of color(s). Let the ink dry, and erase any pencil marks before you send your card on its merry way.

TIP: Plan out your theme or color palette ahead of time, and track down fun stamps to complement your envelope and ink.

VARIATION: Try another layout, using paintbrushes and paint for a fun, casual look.

A Dashing Dinner Setting

PLACE CARDS

Want to add some elegance to a dinner party? Place cards are a surefire way to grab attention. There are two kinds: a tented card, which folds in the middle and resembles a tent when placed on the table, and a flat card, which simply lays flat at the table setting. Premade place cards are often readily available at many art and stationery stores, but you can also easily make your own.

MATERIALS

- Cardstock
- Scissors or X-ACTO knife
- Pencil
- Ruler
- Bone folder
- Paint pen
- Eraser

ALPHABET

- Swell (page 46)

METHOD

1. A folded tent card is typically 3.5 inches wide by 2.5 inches tall, so cut 3.5-by-5-inch rectangles out of the cardstock.

2. With a pencil, lightly mark each card at the 2.5-inch mark, where the fold should go. Place a ruler along the mark and press down firmly so the ruler doesn't move. Run the tip of the bone folder along the ruler, applying pressure to score the card. This creates a clean indented line and makes it easier to fold the card later.

3. Keep your cards flat for now to make them easier to draw on, but remember how the cards will be folded to make sure you draw on the correct side.

4. Sketch each person's name on a card with a pencil. Try lettering freehand and using flourishes to create balance if your names are off-center.

5. Trace over your sketches with a paint pen. I used gold to give the place cards an elevated feel.

6. Add any decorative elements to finish the cards, erase any pencil markings, and you're all set for a swanky dinner!

TIP! If you're using dark place cards and can't see your pencil sketches, try using a chalk or wax pencil instead of a regular pencil for the guidelines.

VARIATION: Get creative with your place cards, and letter on different objects like acrylic, agate, leaves, or whatever fits your dinner theme.

Tote-ally Into It

TOTE BAG

Reusable tote bags have become a must-have—go anywhere that sells anything, and there they are. Here, we're going to make a tote bag a walking work of art *and* rep your city by lettering and illustrating all the awesomeness that is your hometown. It's the perfect way to show off your lettering skills when you're out and about, or you can gift it to a city-loving friend or family member as a souvenir!

MATERIALS

- Scratch paper
- Pencil
- 8.5-by-11-inch sheet of paper
- Tote bag
- Cardstock or cardboard
- Fabric markers

ALPHABETS

- Riley (page 38), Rogue (page 34), Palms (page 30), Daniel (page 18), or Mitchell (page 22)

METHOD

1. First, brainstorm a list of all the awesome things you love about your city, using the scratch paper. What are the words that jump out at you, the images that pop into your head, or the phrases you most often hear?

2. Now, sketch your layout on the 8.5-by-11-inch sheet of paper. Your city name should be the focal point in your composition, with all of the other words or illustrations as secondary or tertiary elements.

3. Once your sketch is ready, lightly draw a finalized version on the tote bag with a pencil, making any adjustments you need along the way.

4. Place a piece of thick cardstock or cardboard inside the tote bag to prevent the ink from bleeding through. Grab your fabric markers and trace over the pencil renderings using short strokes. This allows the thread to absorb the ink and prevents your design from looking streaky. Let the ink set according to the instructions and you're ready to boot, scoot, and boogie!

TIP! Be careful of ink bleeds! If you can, test your markers first before drawing on the tote bag. Sometimes darker colors will bleed into light colors and produce a murky, darker tone than you intend.

VARIATION: Add illustrations to your composition, or keep it strictly text-based for the perfect lettering-lover tote.

Snazz Up Your Space

LARGE-SCALE LETTERING FOR YOUR HOME

Home décor projects are always fun—you can create pieces that match your existing decorations or gin something up for seasonal celebrations. Decorations are easy to swap out, and this project in particular is fairly simple to execute.

MATERIALS

- Pencil
- Scratch paper
- Large-format plain paper (at least the size of your acrylic panel)
- Scissors
- Acrylic panel
- Washi tape
- Microfiber cloth
- White paint pen

ALPHABET

- Swell (page 46)

METHOD

1. First, sketch out a few versions of the phrase of your choosing with a pencil and scratch paper. Remember to think about visual hierarchy and the use of flourishes and decorative elements to fill the negative space.

2. Next, create a template: Cut a piece of the plain paper to the size of your acrylic panel. Draw the phrase on the paper template exactly the way you want your final piece to look, since you'll be using it as a guide for tracing the phrase onto the acrylic panel.

3. Once the template is ready, lay the acrylic panel on top of it. The sketch underneath should be clearly legible and easy to trace. Tape the sketch to the panel with washi tape.

4. Wipe your acrylic panel with a lint-free microfiber cloth to get rid of any errant dust that sticks to the surface.

5. Prep your paint pen on a piece of scratch paper according to the instructions to get the paint flowing through the nib.

6. Slowly trace your design onto the acrylic panel. Double up the down-strokes if you want to create a contrast in line weight. If your pen gets streaky, press down with the tip on a piece of scratch paper to get the ink going again.

7. Let the paint dry completely, and then set your piece on a shelf, mantel, or table and admire your work!

 TIP! If you mess up while painting, let the paint dry, then use your nail to gently scratch off the part you want to repaint.

 VARIATION: Short phrases make great statement pieces, while long phrases are perfect as complementary design elements for any room. Try a version that uses more text, like wedding vows or a favorite poem.

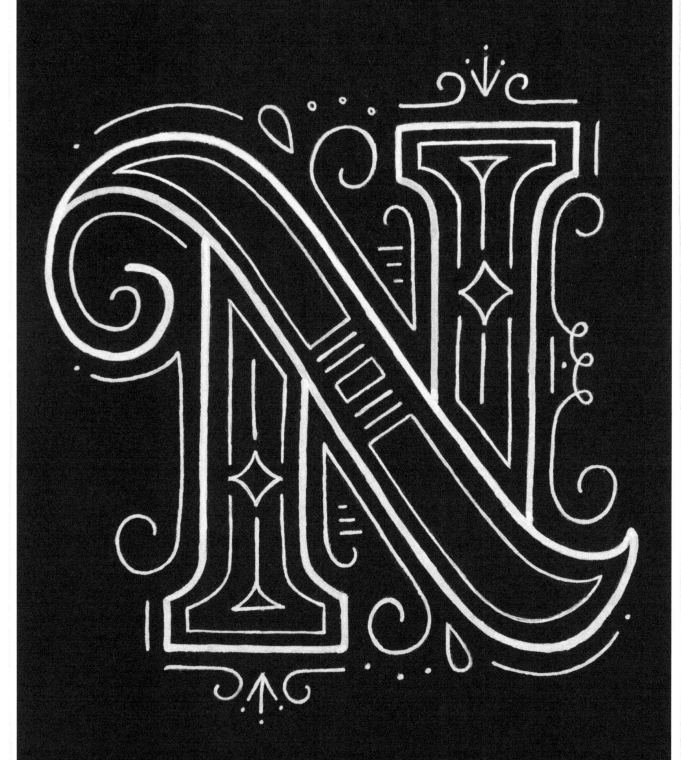

Hello, Fancy Pants

DROP CAP

Some of you might be familiar with the term *drop cap*—a large letter at the start of a word, chapter, or paragraph. Fancy manuscripts in the 8th century often had these illuminated initials with people, animals, or scenes *inside* the letter. These days, hand-letterers create drop caps as stand-alone art pieces. Check out Jessica Hische's passion project, Daily Drop Cap, or the online series "36 Days of Type" for examples. Isn't it cool to see how art forms from centuries ago still influence us?

MATERIALS

- Scratch paper
- Pencil
- Cardstock
- Paint pens
- Gelly Roll pen

ALPHABET

- Palms (page 30)

METHOD

1. You know the drill—break out your scratch paper and pencil, and sketch your heart out. Draw the skeleton of your letter and then add weight, adjusting the width as needed if you're adding embellishments inside the letterform.

2. Once you've got your composition locked down, lightly redraw it to scale on the cardstock.

3. Use a thicker paint pen to draw the outline of your drop cap—you want this to be the first part the eye sees.

4. With thinner paint pens and a Gelly Roll pen, fill in the remaining details and illustrations. I prefer to use metallic colors to mimic the gilded look of traditional drop caps.

 TIP! Paint pens can often be tricky to work with because the paint within the pen will eventually dry out. Keep the lid capped tightly when not in use (and be prepared to buy several more pens).

 VARIATION: If you're giving this project to a friend, try a version that incorporates illustrations of their favorite things or the colors they love the most.

Fill 'er Up!

CUSTOM-DECORATED MUG

Nothing beats a cup of hot coffee first thing in the morning or a warm cup of cocoa on a cold winter night. Snag yourself a plain mug from a thrift or dollar store, turn it into a custom one of your own, and use it as a charming house-warming or holiday gift (or, let's be honest—just keep it for yourself!).

MATERIALS

- Scratch paper
- Pencil
- Plain porcelain mug
- Plain (8.5-by-11-inch) paper
- Scissors
- Tape
- Porcelain paint pen
- Sealant (Mod Podge; optional)

ALPHABET

- Mitchell (page 22) or Riley (page 38)

METHOD

1. Start with sketches using a piece of scratch paper and a pencil. Keep in mind the shape of the mug you're using and how that will affect the composition.

2. Grab a piece of plain paper and trim it down with scissors to the same height as your mug, so you know how much space you have to draw. Sketch your composition on the paper.

3. Flip your drawing over, and burnish (rub) the back side of the drawing with a pencil so the entire area is covered in graphite. (You're going to rub the bits of graphite onto the mug to get a traceable image.)

4. Position the sketch on the mug and tape it down with the graphite side touching the mug and your inked sketch facing you. Trace over your brush lettering with a pencil and press down hard when you go over the lines. You want the graphite on the back side to leave an impression on the mug. Remove the paper once you're done with the transfer.

5. Prep your porcelain paint pen and draw over the pencil guide on the mug. Slow and steady wins this race, as some paint pens can be unforgiving!

6. Let the paint dry completely, and gently erase any pencil markings.

7. You can opt to paint a coat of sealant onto your mug for an extra layer of protection, but be careful—sometimes the sealant will dry streaky.

 TIP! Even with sealant, I highly recommend you always hand wash the mug to keep your lettering intact.

 VARIATION: Try lettering on other homewares, like pottery, bottles, wine glasses, snack bowls, and more.

Coasting By

HOMEMADE COASTERS

Coasters seem like an unnecessary home accessory . . . until you pick up your glass from a wooden table and see the water stains. But don't fret! This tutorial will show you not only how to dress up a coaster with lettering, but also how to make one from scratch. Once you get the hang of this project, you'll be making coasters galore for everyone you know (and your table will thank you).

MATERIALS

- Parchment paper
- Air dry modeling clay
- Rolling pin
- Round (3.5- to 4-inch-diameter) cookie cutter
- Acrylic paint
- Paint pen
- Paintbrush
- Sealant

ALPHABET

- Swell (page 46)

METHOD

1. Lay some parchment paper on a flat surface, and begin by working the clay with your hands to soften it up a bit. Break off a good chunk of clay for each coaster you want to make.

2. Use the rolling pin to flatten each piece of clay to your desired thickness, rolling it out as evenly as possible to a diameter slightly wider than the cookie cutter. Press down with the cookie cutter and remove the excess clay. Let the clay air-dry for 24 hours.

3. Once the clay has set, paint the coasters with a coat of acrylic paint in the color(s) of your choice. Let the paint dry completely.

4. Prep your paint pen and letter the phrases of your choosing on each coaster, making sure to double up on the downstrokes for the faux calligraphy look. Let the lettering dry completely.

5. Paint on the sealant to keep it all intact, and let it dry according to the manufacturer's instructions.

 TIP! You can use different objects to stamp out the clay. For example, a hexagonal cardboard box from the craft store can create hexagonal coasters.

 VARIATION: Twist different colored clays (like white and gray) together before flattening to create a marbled look, or shave tiny pieces off several colors with a cheese grater and flatten the clay on top of the bits to create a confetti design (try white with pink, teal, and yellow).

Fan Favorite

KID'S NAME PENNANT

Kids' decorations are probably one of my favorite things to make. Their bold letters, bright colors and, carefree attitude can lift anyone's spirits. Imperfections are often seen as adorable, and wonky letters can translate to cute and quirky. This project adds a colorful touch to any child's room and is simple enough that your kid can help.

MATERIALS

- 2 (12-by-18-inch) pieces of felt, in contrasting colors
- Ruler
- Pencil
- Scissors
- Scratch paper
- Tacky glue

ALPHABET

- Mitchell (page 22)

METHOD

1. With one piece of the felt lying horizontally in front of you, start by marking the midpoint on the right edge of the piece. (Since the felt is 12 inches tall, the halfway point is at 6 inches.) Draw a line from the top left corner to the 6-inch midpoint on the right and another line from the bottom left corner to the same midpoint.

2. Cut along both lines to create a pennant shape.

3. Trace the outline of the felt pennant onto a large piece of scratch paper. Put the felt aside. Leaving a 1-inch margin on the left side (for the vertical end piece) and a ¾-inch margin on the two long sides, draw a smaller triangle inside the pennant outline. The inner triangle acts as a guide for how big the lettering will be.

4. Take the width of the inner triangle (left edge to right point) and divide that by how many letters are in the name. For example, my inner triangle was 13.5 inches wide, and I needed four letters to spell *Emma*. That meant each letter could be 3.375 inches wide, but drawing them 3 inches wide allowed for some space between each letter.

5. Sketch out big block sans-serif letters on another piece of scratch paper. Cut out the paper letters and use them as templates to cut letters and a 1-inch-thick vertical edge for the pennant out of the second piece of felt.

6. Glue the felt letters and vertical edge to the pennant using tacky glue, and you're ready to rock!

TIP! Once you have the paper template letters cut out, arrange them on the pennant to make sure your spacing is even and the whole piece feels good before you cut the felt.

VARIATION: Use different color felt pieces or add yarn puff balls and tassels to bump up your pennant's playfulness.

All That Glitters Is Gold

EMBOSSED NOTEBOOK

You've probably seen embossing in all its shiny glory on the Internet more times than you can count. So what's the big deal, and why is it so popular? Embossing allows you to create a foil-like effect without spending a ton of moolah. All you need is a surface to letter on, embossing pens (or ink pad and stamps), embossing powder and a heat gun. It's quick, easy, and adds an elevated touch to your projects without breaking the bank. It's tons of fun and will get you crafting like crazy in no time.

MATERIALS

- Plain (8.5-by-11-inch) paper
- Ruler
- Bone folder
- Cardstock
- Awl
- 6-strand embroidery floss
- Embroidery needle
- Scissors
- X-ACTO knife or paper cutter
- Embossing pen
- Embossing powder
- Heat gun

ALPHABET

- Riley (page 38)

METHOD

1. Take a few sheets of the plain paper and fold them in half. To get crisp folds, place a ruler in the center of each page, and lightly score the center fold with a bone folder. This will help the page bend easily. Fold along the scored line, go over the crease with the bone folder, and stack the pages together. Do the same with your cardstock (for the cover), and slip the stack of folded papers inside to make a book.

2. Use the awl to poke five equidistant holes through the spine of your book.

3. Thread the embroidery floss through the needle, but don't knot the ends. You're going to use a saddle stitch to secure the notebook. Starting with the middle hole on the inside of the notebook, pull the thread through, leaving about 2 inches hanging inside. (You'll use this leftover piece to tie everything at the end.)

4. Sew with simple over-and-under stitches from the middle hole to one end of the notebook, then back to the other end of the notebook and finally returning to the middle hole.

5. When you return to the middle hole, your thread should be on the outside. Tie a small knot, and thread the needle back through the middle hole to the inside of the book. Pull the knot through the hole.

6. Trim the embroidery floss with scissors, and use the 2-inch string inside the book to tie a final knot.

CONTINUED

7. When you close the notebook, the edges of the pages probably won't line up nicely. Take an X-ACTO and ruler (or a paper cutter) and trim the edges to match the shortest page so they're all even.

8. On to the fun part: embossing! First, place a clean sheet of paper on the table underneath your notebook to catch any stray powder.

9. Letter your design on the cover with the embossing pen. You can, of course, sketch lightly with a pencil and go over it with the pen.

10. Pour the embossing powder over the entire design. You shouldn't need to use a lot, but definitely sift, shake, and move the powder around to make sure every inch of the design is covered.

11. Put any excess powder back into the container. (I lift my notebook and tap it gently on the paper beneath to shake off all the powder, then create a funnel with the paper and pour the powder back into the jar.) Any stray bits of powder will melt once heated and become part of your design, so be sure to clean off as much as possible.

12. Turn on the heat gun and let it warm up according to the manufacturer's instructions. Holding it 2 to 6 inches away from your lettering, sweep the gun over the image, making sure not to stay too long on any one spot or the powder will bubble and the page will warp. The powder should melt into a smooth, shiny design. And there you go—a personalized, blinged-out notebook!

TIP! Static can cause bits of powder to stick to the surface of your notebook. You might want to invest in an embossing powder bag, which, when you rub it on the page, gets rid of that pesky static cling.

VARIATION: Create notebooks for every kind of person in your life—lined sheets for writers, grid and blank sheets for artists, and a mashup for those who like to journal. You can also add divider pages with your own lettering as a nice surprise, too!

I'm Sew Excited!

EMBROIDERED GIFT BAGS

Have I mentioned how much I love kids' stuff? They're probably my favorite DIY projects, and this one is no exception. Are you hosting an upcoming birthday party? Need a quick teacher's gift? Is there a tiny tot you want to feel special? Here, we combine the cute, colorful, and creative lettering skills you now have to make easy-peasy embroidered gift bags for kids (and let's be real . . . adults, too!).

MATERIALS

- Pencil
- Scratch paper
- 8-by-10-inch muslin drawstring bags
- Embroidery floss
- Embroidery needle
- Scissors

ALPHABET

- Riley (page 38)

METHOD

1. Sketch the lettering with your pencil and scratch paper. If you have a lot of gift bags to make, I suggest keeping things pretty simple to save time.

2. Lightly redraw your design on each muslin bag with your pencil. If the fabric is thin enough and your drawing is to scale, you can ink over the sketch on your scratch paper—just slide it into the muslin bag, and trace your image onto the muslin.

3. Thread the embroidery floss through the needle, leaving approximately 2 inches hanging on one side. We'll be doing a backstitch for this project, but feel free to try a different stitch if you'd like.

4. For each bag, begin your stitch ⅛ inch from the edge of the first letter by bringing the needle up from the inside of the bag (#1), then insert it back down at the beginning of your letter (#2). Pull your thread through, but leave approximately 1 inch of the end of the thread hanging on the inside of the bag so you can tie a knot on the inside.

CONTINUED

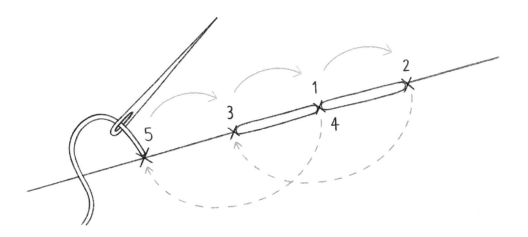

5. Bring the needle back up through the bag ¼ inch farther away (#3) from the first hole, and then thread the needle back down through the first hole (#4). Get it? Backstitch = backward!

6. Once you pull your thread through, tie a knot with the 1-inch piece of thread that is hanging on the inside.

7. Keep going with the same pattern of stitches, following your lettering until you finish embroidering the name. Then, tie off the stitch on the inside of the bag and snip the ends with a pair of scissors. Repeat with the remaining bags. Now you've got super cute, super crafty, DIY gift bags for your guests!

TIP! To create a smooth transition, use smaller stitches when you're going around a curve.

VARIATION: Once you get the hang of backstitching, try using a variety of colors and include other elements in your design (like illustrations or flourishes), opting for different threads or combining stitching techniques for a unique look.

Make It Personal

NOTECARDS

Whether I'm jotting down notes, doodling, or sending something to a friend, writing with my own hand makes me feel more connected than when I rely on my phone or computer to communicate. Custom notecards are the perfect housewarming or hostess gift for someone special (moms and grandmas will love this!). They're a simple but creative nod to the days when hand lettering was about a connection between two people and not just art on a page.

MATERIALS

- Ruler
- Heavy watercolor paper
- Scissors, X-ACTO knife, or paper trimmer
- Watercolor palette or tube(s)
- Pipette
- Large, round paintbrush
- Jar of water
- Small paintbrush

ALPHABET

- Rogue (page 34)

METHOD

1. Cut 4-by-6-inch rectangles out of the watercolor paper.

2. If you're using a watercolor palette, add a few drops of water to your color of choice. I like to use a pipette (check your local art store) to control the amount of water. Let it sit for a few minutes to achieve more saturation. If you're using a tube of watercolor paint, mix together the paint and some water in a dish. Test the consistency on a scrap piece of watercolor paper. You want the paint to appear slightly opaque when applied to the page.

3. For each card: Dip the large, round brush in the jar of clean water, and paint a wash on the bottom quarter of the notecard.

4. Dip the large paintbrush in some watered-down pigment, and paint a horizontal line halfway down the wash. The color should bleed above and below the line.

5. Add more pigment to the large brush, and paint another line of color at the bottom of the notecard. This should have more pigment than the previous stroke, so the colors will go from light to dark, top to bottom when it dries. Set the notecard aside to dry.

6. Once the cards are completely dry, take your small paintbrush and letter the phrase of your choosing at the top of the card. Easy peasy!

 TIP! If your notecards curl because of the water and paint, simply flatten them in the middle of a stack of heavy books once they're dry.

 VARIATION: Turn this project into a to-do list instead. Just add checkboxes and lines to the page!

Colorful Chaos

OMBRÉ WATERCOLOR QUOTE

Ombré effects aren't just great for hairstyles; they're the perfect technique for blending watercolor paint in an organic way, melding from one color to the next. Watercolor is much more forgiving than other paint media when it comes to making adjustments on the fly. With water, you can coax the paint to shift and move. But since you have no real control over what happens when the pigment mixes with liquid, the effects are unpredictable and harder to replicate. Use this to your advantage, and create a unique piece of art.

MATERIALS

- Watercolor palette
- Pipette
- Jar of warm water
- Scratch paper
- Pencil
- Heavy watercolor paper
- Paintbrush

ALPHABET

- Seaside (page 42)

METHOD

1. Prep your watercolor palette by loading a pipette with warm water and adding a few drops to the colors you'll be using. Start with a rough idea of the overall color scheme.

2. Take your scratch paper and pencil and sketch out a few compositions.

3. When you find a layout that you want to paint, lightly redraw it on the watercolor paper as a guide. Try not to press too hard with the pencil. Your marks might appear more obvious once the watercolor dries.

4. Since we want an ombré effect where the colors blend into each other, we'll change colors as we paint, while the previous stroke is still wet on the brush. To do this, load your paintbrush with the first color, and paint over your guideline with a single stroke. Before the paint on the paintbrush runs out, pick up the second color and continue from your first stroke into the next stroke. Be sure to overlap the two colors so they blend on the page. Continue painting and blending until you finish your piece.

TIP! Remember to overlap, overlap, overlap! You can coax the colors to blend further with the addition of water.

VARIATION: Try using watercolor pencils. Draw as you normally would, then brush over your strokes with a wet paintbrush to get a similar but more controlled effect.

TIP: Safety first! Always carve away from your body. Instead of rotating your tools when you're trimming around curved areas, rotate the carving block to keep the carving motion consistent and the cut lines smooth.

VARIATION: Try a version with your lettering inside a shape, like a circle or a speech bubble. If you want your stamp to be filled in, carve the letters out of the block instead of carving around the letters.

Lady & the Stamp

RUBBER STAMP

If you haven't figured it out the hard way yet (like I have . . . several times over), stamps can be your BFF. From gift bags to hang tags, greeting cards to favors, they're the easiest way to get that DIY vibe without putting in painstaking effort every single time. In fact, custom stamps saved my life during our pre-wedding days—I used them for the return address on our invites and RSVPs, and I created a separate design for our guests' welcome gift bags, too. Here's hoping this tutorial comes in handy for your special occasions!

MATERIALS
- Scrap paper
- Pencil
- Speedball Speedy Carve Kit
- X-ACTO knife
- Ink pad

ALPHABET
- Mitchell (page 22)

METHOD

1. First, decide on the size of your final design and draw it on a piece of paper, making sure the lines are fairly dark. Carving can be tricky, so start with a fairly simple design; the thicker your lines and lettering, the easier it will be to carve. The Speedball kit has all the tools you need.

2. Place your design face down on the carving block and burnish the back of the page with the pencil to transfer your drawing (see page 80).

3. Use an X-ACTO knife to cut the stamp down to size, leaving a ¼-inch border around your stamp.

4. Now, carve away the parts of the stamp you *don't* want to show, leaving your desired design behind (it'll be the reversed image on the stamp). Start with the larger (#4) blade and carve away the outside of your design, keeping the blade at a low angle to scoop and shave down the areas you *don't* need. Carve away from you and be careful not to carve too deep.

5. Once you've completed the outline, take the thinner (#2) blade and carve away the rest of the negative space outside of your design.

6. Continue to carve around your lettering, including the inside of any bowls or ascender loops. I prefer to use an X-ACTO knife for cleaner cuts in hard-to-reach places.

7. Test your design by pressing it onto an ink pad and stamping onto a scrap piece of paper. If you notice any stray ink marks on the page, you can go back and shave those bits off your stamp.

Chalk Full of Fun!

CHALKBOARD SIGN

From coffee shop menus to restaurant signage, murals to art installations, weddings to kitchen walls, chalk lettering is practically everywhere. It's inexpensive and affordable, and fixing mistakes is such a breeze that everyone and their mom can get in on the artsy action. I especially love that the medium isn't permanent, which means you can keep working your design until it's perfect. Plus, with the creation of chalk paint, any surface can become a canvas for your lettering skills.

MATERIALS

- Picture frame with glass
- Newspaper or cardboard
- Chalkboard spray paint
- Scratch paper
- Pencil
- Chalk pencil
- Microfiber cloth or cotton swabs
- Chalk marker

ALPHABET

- Palms (page 30), Riley (page 38), or Daniel (page 18)

METHOD

1. First, you need to make the chalkboard. Carefully remove the piece of glass from the frame and clean it thoroughly.

2. Place some newspaper or cardboard on the ground and lay the glass on top. Follow the instructions on the chalkboard spray can to prep the paint properly. (I prefer spray cans over brush paint because they give a smoother finish.)

3. Spray the glass with the chalkboard paint, using long, sweeping motions. Let it dry completely, and then add at least one or two more coats. I like the paint to be thick enough that it won't reveal the glass underneath if I accidentally scratch the surface.

4. While the paint dries, sketch out your lettering using scratch paper and a pencil. Remember to think about hierarchy and decide which parts of the phrase you want to stand out.

CONTINUED

LET'S MAKE *Today* THE **BEST** *Day Ever*

5. Once the chalkboard is ready, lightly sketch your design on the surface with a chalk pencil. Remember that you can make adjustments along the way—just wet a microfiber cloth or cotton swab to erase the parts you want to fix.

6. When your sketch is in a good place, grab the chalk marker and prep it according to the instructions. I prefer chalk markers to sticks of chalk because the linework is cleaner and more vibrant, but use whichever you prefer.

7. Go over your sketch with the chalk marker. Once you're satisfied, use a wet microfiber cloth or cotton swab to clean up any stray marks one last time.

TIP! Similar to paint pens, chalk markers can be finicky and may require several mid-paint stoppages to get the ink flowing nicely through the nib. Be patient! If you're using chalk sticks, you can wet the stick and sharpen like a regular pencil to get a fine point.

VARIATION: While white chalk on a black board is my favorite, try creating the same piece using colored chalk on black or colored chalkboard paint for your background.

Depth Perception

3-D LETTERING

Learning the basics of lettering is tons of fun, but now it's time to test your comfort zone by adding some dimension. Have you gotten to the point where you're working on a piece but realize that something's missing? This is where dimensional lettering can save the day. Three-dimensional elements are a great way to make your letters pop off the page and grab the viewer's attention.

MATERIALS

- Wood panel
- Large paintbrush
- Acrylic paints (white or a light color for the background, and medium or dark for the lettering)
- Pencil
- Scratch paper
- Chalk pencil
- Ruler
- Small round paintbrush
- Medium round paintbrush

ALPHABET

- Mitchell (page 22) or Riley (page 38)

METHOD

1. Paint the wood panel with a large paintbrush and your background color. It's best to use a lighter color for the background so the lettering stands out. Let the paint dry completely.

2. While the paint is drying, sketch out your composition with a pencil on a piece of scratch paper. Use a combination of different lettering styles. For 3-D effects, big block letters are best. (Think of block letters like really fat sans-serifs.)

3. Next, practice 3-D lettering (see page 17 for more details). You can create a 3-D effect that angles to the right, left, or down. For letters that extrude on their right side, draw short lines off every right-facing corner, and connect those lines. Don't forget the insides of your letters!

4. Now that you've got the hang of it (if you don't, keep practicing!), use a chalk pencil and ruler to lay down some guidelines and sketch out your composition on the wood panel.

CONTINUED

5. It's best to work from the bottom up in layers when it comes to painting 3-D lettering, so fill in your darkest drop shadows first, using the medium brush. Clean your brush, and let this section dry completely.

6. Continue painting the next layer—the extruded 3-D layer—and let it dry completely. Keep building your way up!

7. To emphasize the shadows in your 3-D extrusion, first picture an imaginary light source above your illustration. Where would the light hit, and where would it create shadows? Clean your paintbrush, and use a slightly darker color to paint those shaded areas in. Wash the brush, and let the paint dry completely.

8. Continue painting your next layer, wait for it to dry, and then add some details. Paint an outline of your block letter with a small paint-brush, then let it dry completely. Clean the paintbrush.

9. Finally, using the small paintbrush again, this time with the dark color, draw a thin inline within the block letters. Voilà! You've got a 3-D piece to hang in the house or give to a friend.

TIP! Paint can be tricky to work with, so take your time. Acrylic paint is opaque, so let the paint dry before you try to fix mistakes, and be sure your brushes are clean to avoid mixing and muddying your colors.

VARIATION: Now that you know how to paint in layers, how many layers can you build for your future 3-D letterforms? The possibilities are endless!

LET'S Make SOME Magic

Create Your Own

Now that you have the tools and basics down, and you've tried your hand at some lettering projects, it's time to explore and experiment. You're going to apply the knowledge you've learned in the previous chapters to find your own artistic voice and style.

Take a moment and think about what you're drawn to aesthetically. If you enjoy keeping things visually lighthearted and fun, a bouncy script might be right. If you like the elegance of traditional calligraphy but don't want your work to look so rigid, try a style that incorporates flourishes. Want to keep things casual? A sign painted in sans-serif style with bold brushstrokes could be a great fit.

Personalize Your Alphabets

We can create plenty of variety in one style by changing a few characteristics. Using the Rogue alphabet (page 34), explore the effects of making minor adjustments to just one word: contrasting the weights of upstrokes and downstrokes, adjusting the kerning (space) between letters, shifting the baseline of the alphabet, or even changing the angle at which you draw the letterforms.

ORIGINAL

TIP #1 – CONTRAST

Create a version with contrasting stroke weights: double up your downstrokes or minimize the contrast between the downstrokes and upstrokes. High-contrast letterforms tend to add emphasis and catch the reader's eye, but may be harder to read at smaller sizes.

HIGH STROKE CONTRAST LOW STROKE CONTRAST

TIP #2 – KERNING

Try adjusting the kerning between each letter. If the distance between the letters is increased, the word feels more drawn out (literally), and if the distance is decreased, the word feels cramped and condensed.

LOOSE KERNING TIGHT KERNING

A straight baseline is, well, straightforward and predictable. When we change the baseline from letter to letter, the word has more movement and appears to bounce on the page.

Cake *Cake*

SLANTED BASELINE VARIED BASELINE

TIP #4 — ANGLES

Draw at a steeper angle, and the word becomes instantly more emphatic than before, creating a sense of urgency. This is why italics are used to grab the reader's attention in long blocks of text.

Cake *Cake*

SLIGHT SLANT EXTREME SLANT

Create Your Own Alphabet

There are an infinite number of ways to create your own alphabet, and no one way is right or wrong. Tinker a bit, and you'll find what makes the most sense for you.

TIP #1 – START WITH WHAT YOU KNOW

Decide whether you want to create a serif, sans-serif, or script style. Then, begin drawing the lowercase alphabet (this is my personal preference), making mindful decisions about the shape of the letters. Keep your angles the same—if you tend to write upright, stick with that. If you turn your page at an angle (like I do), explore that version first. Do what comes naturally, and expand from there.

a b c d e f g

h i j k l m n

o p q r s t u

v w x y z

All the letters in an alphabet should look like they come from the same family, so you'll need to make decisions and apply them throughout. Will your shapes be thin or thick, short or tall, sharp or soft? Are all your ascenders loopy or straight? Do the cross strokes of your Fs and Ts sit high or low? The rules you establish should also apply to capital letters, numbers, and the ampersand.

a b c d e f g

h i j k l m n

o p q r s t u

v w x y z

The wonderful part about creating your own style is that YOU get to decide the mood or tone you're trying to convey, and your alphabet can reflect those feelings. Serifs and sans-serifs are straightforward, but change their height, width, or baselines, and they're instantly more playful. Script letterforms are artistic and expressive, but if the letters are kept within strict guidelines, they can feel more formal.

ADD LOOPS TO
ASCENDERS

KEEP LETTERFORMS CASUAL

CREATE LOOPS
WITH DESCENDERS

USE LONGER
HORIZONTAL STROKES

Once you have an alphabet you're pretty proud of, try variations by applying different rules to one word so you can see the difference your decisions make. For example, try drawing the same word with a short x-height, or with a tall x-height, with little or lots of space between letters, with a bouncy or straight baseline, and so on. What other ways can you switch things up?

ORIGINAL

SHORT X-HEIGHT MORE SLANT

TALL X-HEIGHT 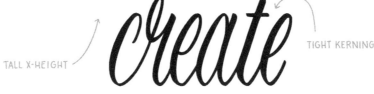 TIGHT KERNING

LOOSE KERNING 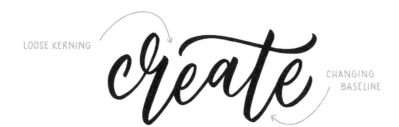 CHANGING BASELINE

Combining Alphabets

Sometimes it makes sense to mix and match different lettering styles. Stylistic choices also help with hierarchy, legibility, overall composition, and tone. Not quite sure what I mean? Think about products you've used or seen. Wedding invitations, for example, often pair traditional copperplate calligraphy with a serif typeface to emphasize formality. Children's books use sans-serif fonts and hand-drawn styles to appear approachable and fun. Shapes and styles can express as much visual information as the text itself.

TIP #1 – STRONG & BOLD

Sans-serif lettering styles are clean and simple, but they can also pack a punch.

TIP #2 – TRIED & TRUE

Sans-serifs paired with serif styles are a classic combination. The pairing creates an interesting visual contrast that instantly draws you in.

THE Darkest Nights PRODUCE THE Brightest Stars

— JOHN GREEN

TIP #4
**ELEVATED
& ELEGANT**

TIP #3 — SOFT & SWEET

Scripts and sans-serifs are great if you want something fun and friendly but without all the frills.

TIP #4 — ELEVATED & ELEGANT

Script and serif styles exude formality but don't have to be stuffy. Pair a modern serif with a casual script style and you'll end up with something fun and fresh!

Go Create!

OHMYGOSH, you did it! You've made it to the end of the book and have hopefully learned amazing things about lettering, the fundamentals of typography and design, and the creative process that guides all of it. (Bonus points if you had tons of fun, too.)

If there's anything I hope you remember, it's that you should stay true to who you are and what brings you joy. There may be tons of lettering artists out there, but there's only one of you, and you're the only one who can do things exactly how you do them. Embrace that and let it show through your art.

I'm so grateful to have been able to share what I've learned with you, and I hope this book remains a valuable resource for you for years to come. Remember to practice mindfully, take your time, try new things, and explore your creativity. You've got all the tools you need, so go for it!

Index

Acknowledgments

I'm so thankful for the opportunity to write this book, and I'm thankful to you, the reader, for allowing me to share the knowledge I've learned over the years. This is truly a dream come true, and I'm especially grateful to the entire Callisto team for making this process enjoyable and for helping turn that dream into reality.

Thank you to my family for their endless encouragement, for pushing me to work hard, and for never doubting my artistic skills; to my teachers and professors, for keeping my love of creativity alive; to Taj Tedrow, for the invaluable lessons in life, design, and business; to Brooke Robinson, founder of Goodtype, for graciously contributing the foreword, and whose early support gave me confidence in my craft; to my favorites—Marco Franzitta, Nina Fiore, Corey Fajerski, and Nate Kreiter—for filling me up with much-needed laughs, hugs, and warm fuzzies when I need them the most; to Flapjack, our furry feline, for lighting up my days with his ridiculous antics; and a very special, heartfelt thank you to my husband, Nevin, for all the kindness, support, understanding, and unending love you've given me from day one, no matter what.

About the Author

JOANNA MUÑOZ is a Los Angeles–based art director and designer, and the artist behind Wink & Wonder. She discovered lettering in 2013 and quickly fell in love with the craft. Combined with over a decade of experience in the creative field, Joanna has since turned her lettering hobby into a steady freelance business working with local, national, and international clients ranging from bridal magazines to greeting card companies, film studios, and more.

CPSIA information can be obtained
at www.ICGtesting.com
Printed in the USA
LVHW051610081218
599731LV00002B/4/P